# FORWARD MOVING SHADOWS

# FORWARD MOVING SHADOWS

## A Tanka Memoir

**Poems by Peggy Heinrich**

**Photographs by John Bolivar**

iUniverse, Inc.
Bloomington

# Forward Moving Shadows

iUniverse books may be ordered through booksellers or by contacting:

iUniverse
1663 Liberty Drive
Bloomington, IN 47403
www.iuniverse.com
1-800-Authors (1-800-288-4677)

ISBN: 978-1-4759-3809-8 (sc)
ISBN: 978-1-4759-3892-0 (ebk)

Printed in the United States of America

iUniverse rev. date: 07/17/2012

## ACKNOWLEDGMENTS

For helping me find the tanka in my words, I am grateful to the following members of the Grand Central Tanka Café: Stanford M. Forrester, Marilyn Hazelton, Dorothy McLaughlin, Pamela Miller Ness, Marian Smith Sharpe, Christine Shook and the late Allen Terdiman; and more recently to my co-conspirators in California: Patrick Gallagher and Joan Zimmerman.

For their excellence of eye and ear to the entire collection, I wish to offer thanks to my daughters, Nicole and Jean.

I greatly appreciate the support of the editors of the following publications in which these tanka have appeared, some in slightly altered form.

American Tanka; Ash Moon Anthology; Atlas Poetica; bottle rockets; Catzilla; Concise Delight; Eucalypt; Grand Central Station Tanka Café chapbooks: *unrolling the awning, only the bulbs, the still green horizon;* gusts; hummingbird; Kozue Uzawa website; lilliput; Magnapoets; moonbathing; moonset; Nectar Untouched (Ichi Tanka Gang chapbook); Nisqually Delta Review; Notes from the Gean Tree; Poetry in the Light; Presence; Prune Juice; Raw Nervz; Red Lights; Ribbons; Ridge Whisperings Anthology; Shreve Memorial Library Electronic Poetry Network; Simply Haiku; Sketchbook; Take Five: Best Contemporary Tanka, 2008, 2010, 2012; Tanka Society of America Newsletter; Tanka Gourmet; Tanka Journal; Tanka Pool; The Temple Bell Stops: A Collection of Contemporary Death Awareness Poems; TSA members' anthologies, Searching for Echoes (2003), something like a sigh (2005), TSA Newsletter; TSA Website; Tanka Splendor; 25 Tanka for Children (Atlas Poetica 2011); winfred press calendar; Wisteria.

Several of these tanka also appeared in my book of poems, A *Minefield of Etceteras,* (iUniverse, 2006).

Awards: Moonset, 1st prize, November 2007; republished in the Ash Moon Anthology on aging, 2008.

## INTRODUCTION

Although tanka preceded haiku in Japan by some 1300-1400 years, it entered my world long after I discovered the three-line form. When it did, I was drawn immediately to the possibilities it offered to express personal thoughts and feelings in addition to its more objective lines. The tanka in this collection focus on growing up to growing old with intervals dominated by raging hormones and random thoughts.

Like haiga, where a visual image enlarges the haiku with a connection that is subtle and rarely literal, each of John Bolivar's photographs reveals its own tale, matching the tanka it is paired with, as Emily Dickinson famously said, by telling the truth but telling it slant.

# sound of summer rain

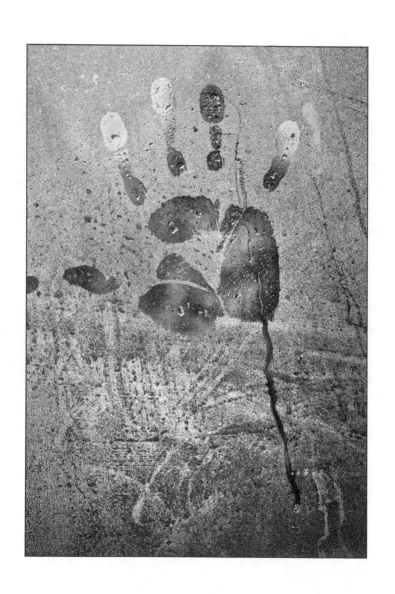

I wake to the sound
of summer rain—
before leaving for work
my father quietly closed
my window

old home movies
mother still dancing
the Charleston—
day-long snow
fogs the window

winter darkness
recalling all the things
she taught me
and how
I wouldn't kiss her

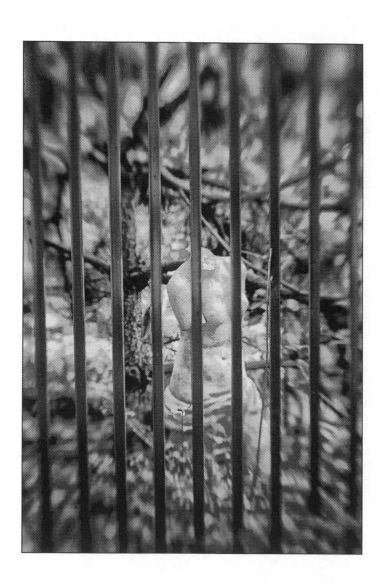

garden walk
the little girl shares a secret
with her mother:
        the pleasure spot
        she's found

                in my teens
                despite the fear
                I used to pray
                *don't let me die*
                *a virgin*

                        warm fireside—
                        sorting through old photos
                        I try to know
                        the young woman
                        who was my mother

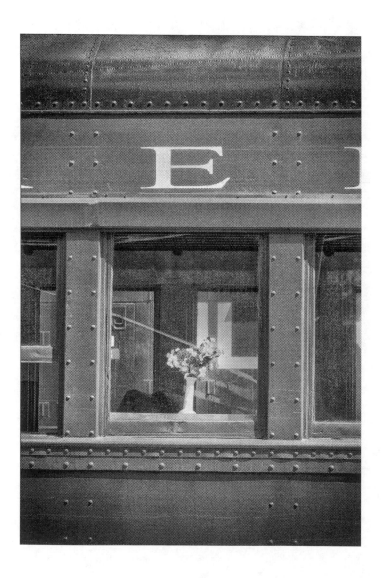

each summer
our trip to the beach
on seats of woven straw—
I remember the going
and not the coming-home

beach safari—
umbrella, chairs, food, drinks
and a child wondering
how will she manage this
some day

icicles
on my birthday
the warm thought
that they made love
in May

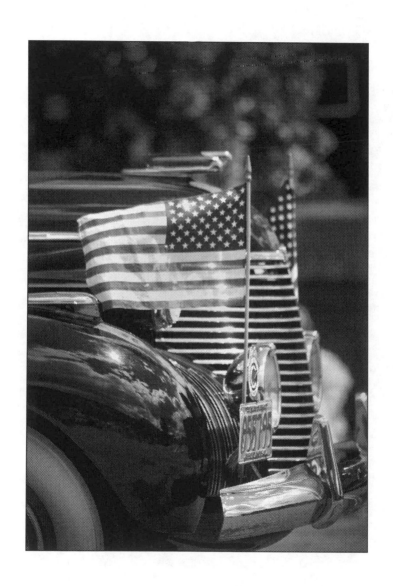

moments before
the parade passes by
at the beat of the drums
the blare of the horn
I weep and don't know why

even before Hitler
my parents talked about
*where we're not wanted*
my parents loved me
why didn't everyone?

Father hid each day
behind *The New York Times*
still I want to nest
my small hand in his
my full-grown hand

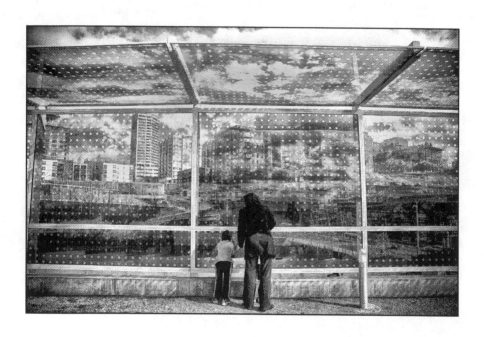

city girl—
discovering the sun sets
past a different part
of her window
each day

my indifference
when Dad took me to lunch—
I revel in recalling
his silly jokes
his laughing eyes

New Year's Eve—
in the hall closet
the price tag
on mother's new silk dress
still dancing

in the dream
a woman I've never seen
yet somehow
I know
she is my mother

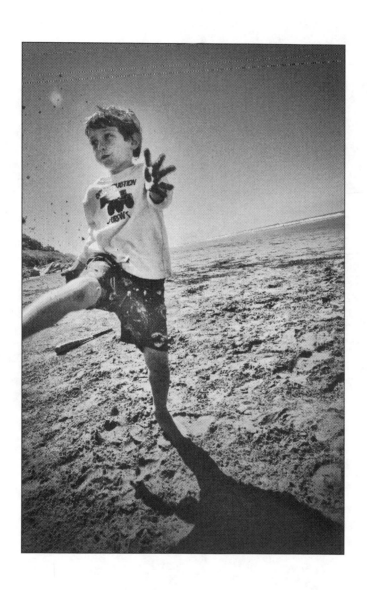

my brother
always being scolded
for his behavior . . .
I became a good girl
to live my lies in peace

exchanging memories
my brother and I disagree
about our childhood—
　　a summer breeze
　　scatters beach sand

long and friendly
this telephone visit
with my brother
our spitefulness
when we were young

warm June day
I pack the car and set out
still pondering
which bridge to take
to reach my brother's house

strong rain
rips leaves from the maple . . .
I book a flight
deciding not to wait
for your funeral

Seattle earthquake—
the kindergarten class scrambles
beneath shaking tables;
from one small voice:
*Don't worry, it's just practice.*

cloudy afternoon—
the ESL student wants to know
the difference between
*no problem* and
*it's out of the question*

he flies in fast
then darts away
nectar untouched;
just when you're enjoying yourself
something flies in to scare you off

low-hanging fog . . .
I mention spirit guides
and hear iron gates
in her mind
clank shut

lifelong friends: hopscotch,
sex manuals, therapy, kids,
widowhood, birthdays—
the same moon shifts its form
the same stars light the sky

her poem
all those men
all those beatings
she stares at her hands
murmurs, "It's not really true."

the Japanese chef
catches the egg on his knife
cracks it on the grill . . .
my friend describes the fight
with her husband

# fog on the day we met

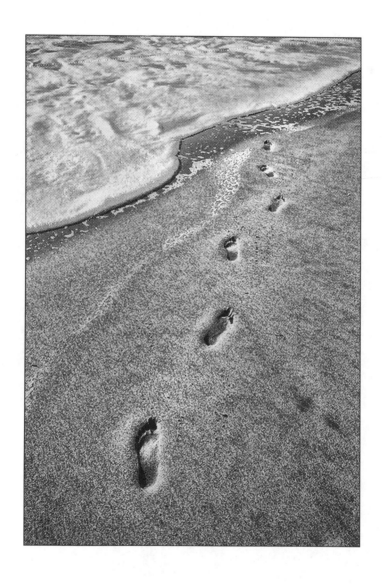

emptying drawers
full of loose photographs
there we are
at the beach at Point Reyes
standing apart

after the argument
I flee to the beach
breath calmed
by the egg-shape
of black stones

tonight a full moon
brightens the lane
I never told you
I thought it a bad sign
fog on the day we met

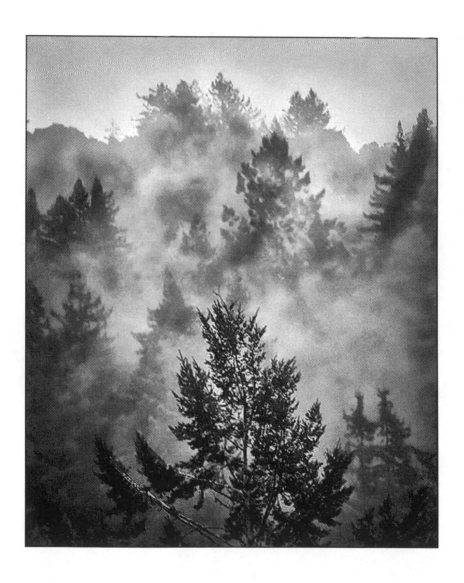

waking to find
the world beyond my window
erased by fog
    I hope it's not
    a metaphor

        on the moon's chin
        that strange smudge spreads
        into an eclipse . . .
        how scratchy and rough
        my husband's beard has grown

                the chestnut's dual trunk
                heads separate ways
                touching other trees
                    all those times
                    he failed to come home

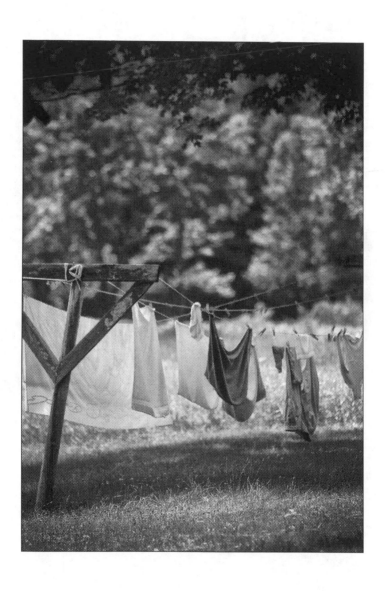

old Bible
recording generations
of births and deaths—
mine was the first divorce
in our family

       *too young,*
       my parents said,
       and when
       the marriage fell apart
       I never told them why

              busy intersection
              for months the red light's
              been telling me to stop . . .
              lately I feel it's saying
              *get set, honey, to move on*

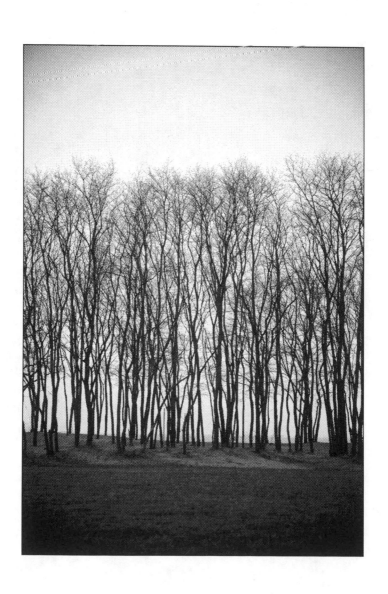

gray winter day
early humans
must have wondered
if trees would bud again
and so do I . . . so do I

                    each day the tide
                    flows in, flows out
                    past the summer house—
                    how strange, this feeling
                    that things will never end

                              meditation walk
                              slow enough
                              to notice
                              small white clover
                              held in the grass

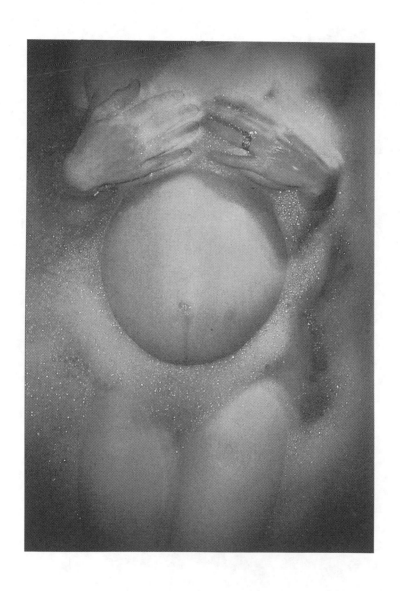

I ate the moon
soon I will give birth
to a moon baby
I swoon under the weight
of my good fortune

        two daughters
        on the far coast—
        it's when we're together
        knowing it won't last
        that I miss them

    Christmas visit
    my daughter offers a massage
    as she touches my belly
    I wonder if she also thinks
    of her first home

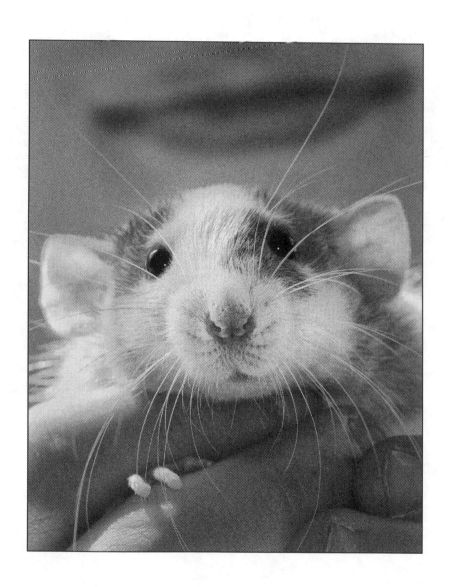

in the half-filled pitcher
a mouse treading water . . .
what shall I do
with this small life
in my hands?

a homeless woman
moves through the subway car
begging
I close my eyes
and count the stops

my friend uncovered
in her coffin
throughout the service
a starling flies
among the rafters

New Year's Day
on this island
of steel and glass
the sound of beating wings
grows louder

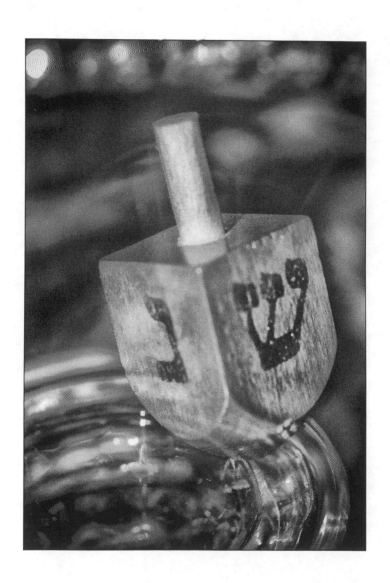

Hanukah
before we lit the candles
we each bet on one
to burn the longest . . .
I chose you and lost

Bird of Paradise
flares his chest feathers
brilliant red and green . . .
what was it you did
to lure me so strongly?

in your mind you played
with numbers, drove a golf ball
straight for miles
but you couldn't talk about
your love or your despair

halfway to the meeting
I drove back to be with you—
did I know somehow
you'd be gone, suddenly,
in just two days?

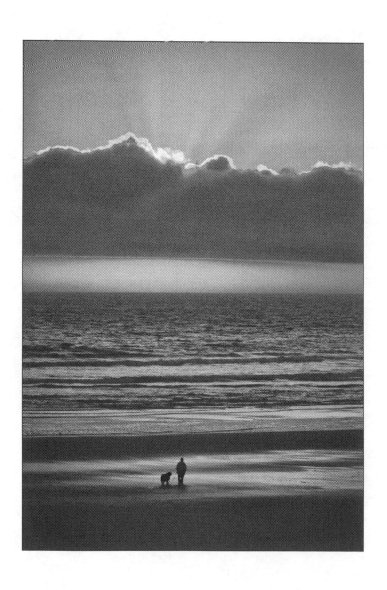

for the first time
I find myself
alone
and yet . . .
winter sun

home from his funeral
our young neighbors
look the other way
    in my garden
    clusters of daffodils

all night long our kisses
in my childhood closet
husband too soon lost
come back another night
to love me in a dream

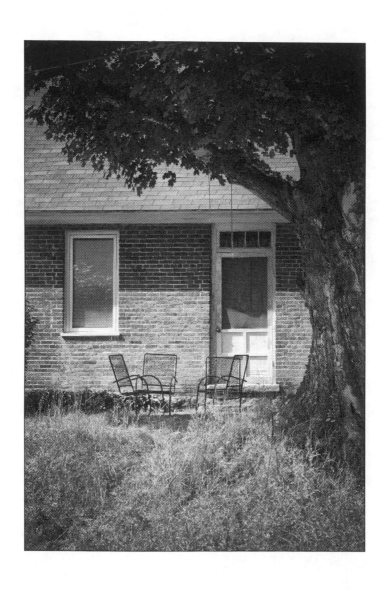

moving day
the last piece of furniture
goes into the truck . . .
where the feeder once stood
finches pick at seeds

you fell from the sky
left me your last name
& two dancing daughters
I thought you would stay longer
but you returned to the sky

dark city street
the red light
of an ambulance
grows larger
grows smaller

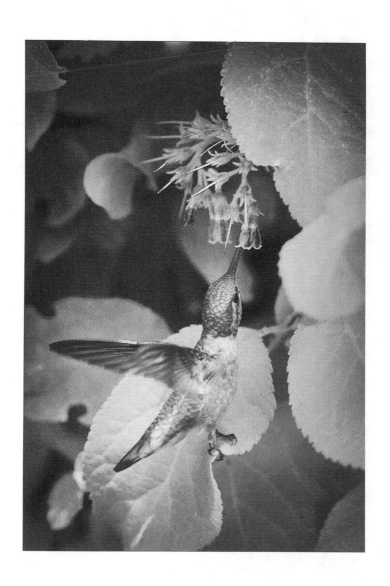

hot summer day
the sliding screen door
sticks in mid-track
    in sunlight the flash
    of a hummingbird

        strong
        until a movie matinee—
        when the actor
        strokes his lover's hair
        my sudden tears

                outside the glass door
                a giant spider web—
                reluctant to tear it
                I choose
                another path

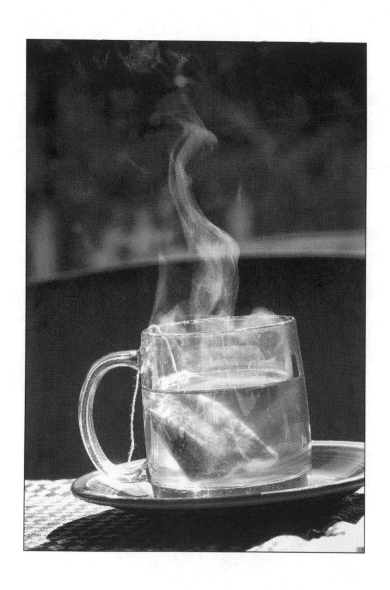

table for one
on this winter day
the fortune cookie
reminds me
*you have many friends*

in a dream
I meet
a marvelous guy
in a parallel universe
I'm having a wonderful time

this former lover
slips back into the cracks
of my life—
what happens next,
mid-winter sun?

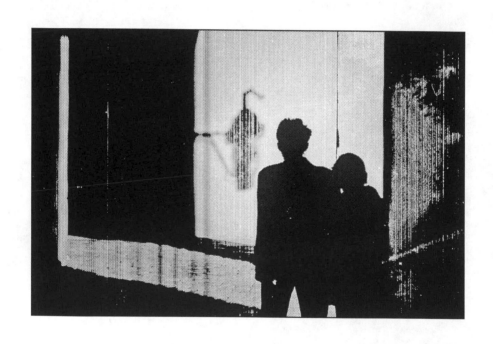

he writes
*after so many years*
*nothing's impossible . . .*
I reread the phrase
feeding on possibilities

        I gather hints of love
        with each rereading of his mail
        how warming
        even printed words
        to icy loneliness

unspoken thoughts
of what we almost did
many years ago . . .
I lean into your arm
around my waist

        city park
        barefoot on new grass
        drawing tight
        against each other
        like strong, strong magnets

# silent carousel

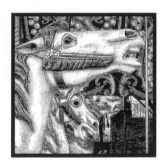

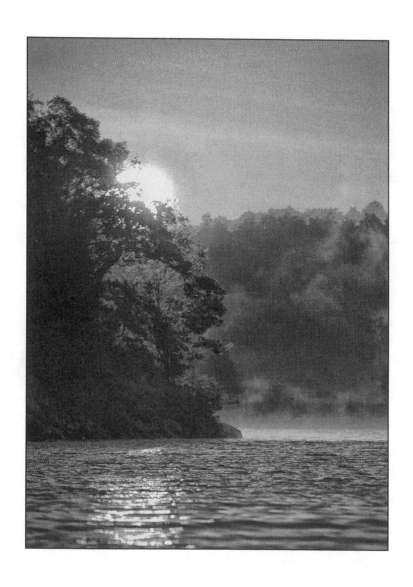

great god
of mountains and mudslides
thank you
for blessing these hills
with your gift of soft soft rain

he walked up my driveway
a painting under one arm
a gift of himself
soft blues and whites
uniting sea and sky

New England hillside
trees once thick with green
aflame with red and orange—
this flash of light
before the dark

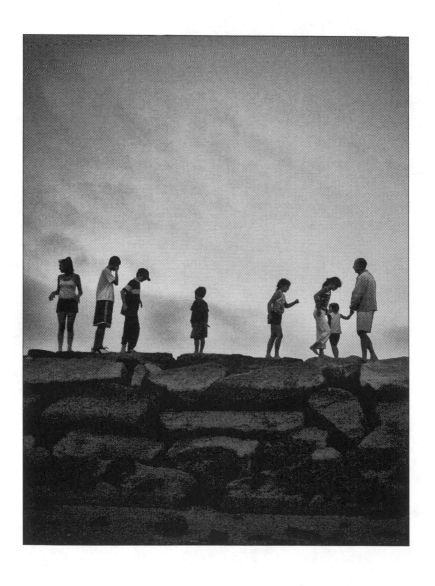

seaside café—
he refuses my offer
of vitamins,
says I'm interfering
with his death

        in a darkening room
        he laments his childhood
            in the front yard
            the mimosa he planted
            teems with blossoms

I can reel off jobs,
books I've read, men I've loved—
how comforting
to sail through memories
blind to icebergs floating by

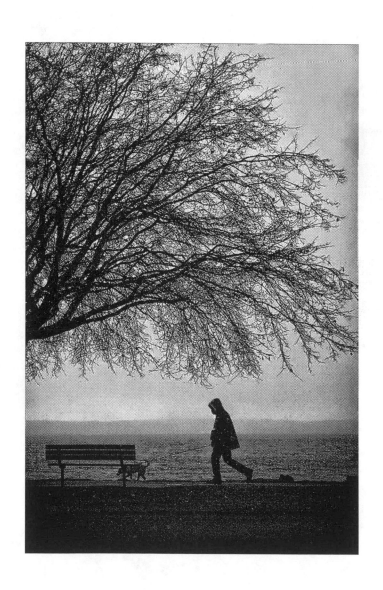

every day
at every bush, every tree
our dog stops to sniff . . .
*don't rush him,* my husband says,
*he's reading the newspaper*

after his death
I leaf through photos
of the galaxy
our earth too small
to find

alone at the window
I watch lightning
tear the sky
again the thought
he would have loved this

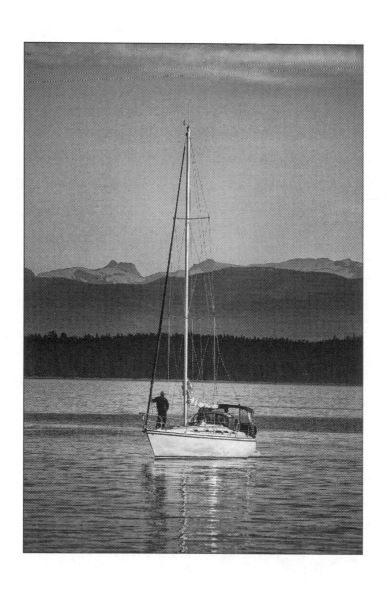

all I saved
his wool seaman's cap—
he dreamed of sailing
around the world
alone

        each day he struggled
        to catch the sea on canvas
        but the sea caught him—
        angry waves pound rocks
        silent tides reflect the moon

                digging up iris
                to divide them . . .
                was it better
                to discover his lie
                after he died?

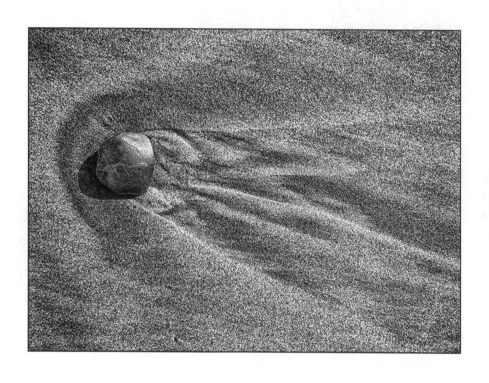

last winter
we laughed at long shadows
cast by small stones—
I no longer smile
at dark shapes on sand

       redtail hawks
       after the smaller one crashed
       into the window
       the other one flew past
       again and again

hot summer days
we unrolled the new awning
laughing at its complexities
. . . who will help me open
and close it this year?

       now that he's gone
       who can I tell about
       that whiff of tobacco
       those sounds from the drum
       this dream?

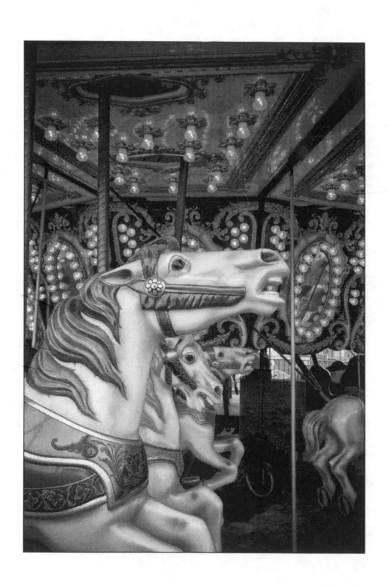

he enters smiling
astride a pale horse—
a silent carousel
spins him back to life
inside my dream

today
missing him
I try to recall
one of our arguments
autumn chill

dropping
the sweater I knit him
into the Goodwill bin . . .
a snow plow
clears the road

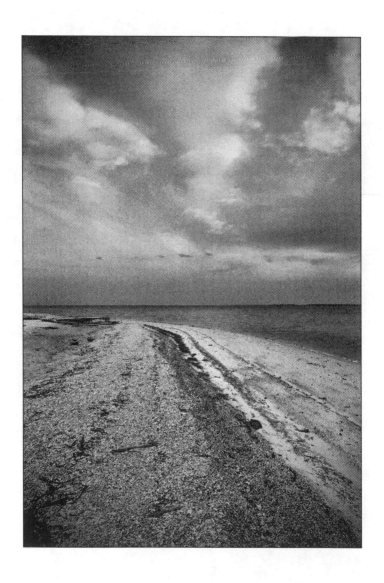

a snail
in its shell
at the tide line
I count up
the places I've lived

as a child
I wondered
what kept the moon in the sky
now that I know
I am no happier

winter darkness
out of dozens of thoughts
one grows wings—
nothing matters
but these words

I ask
the small gray stone
if it would like
to come home with me
and receive an answer

      believing I can do it
      I hold the silver teaspoon
      in both hands . . .
      when it bends
      my gasp of surprise

          her words to the hypnotist
          as she slips back and forth
          between lives
             *it's harder to be born*
             *than to die*

    at times playing bridge
    I merge with a Roman soldier
    slapping down cards
    in a strange world
    with its thin veil of time

          after the message
          the long silence
             *when you get here*
             *you'll discover you*
             *were the dead ones*

wind carries messages

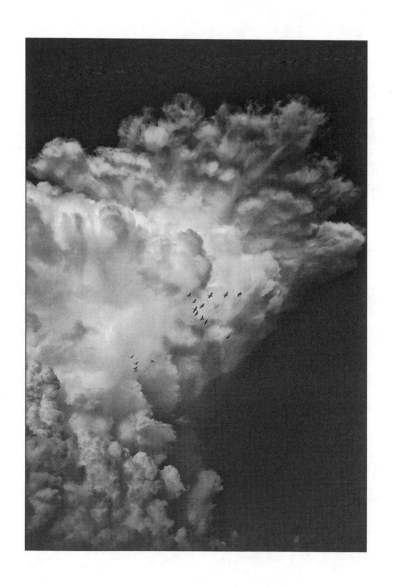

threads of milkweed
sail across the meadow . . .
stand in one place
close your eyes
wind carries messages

     packing
       for a cross-country move—
        don't worry
         memories
          you'll fly free

          starting anew
          on the other coast
          a strange spotted bird
          picks up crumbs
          beside the sea

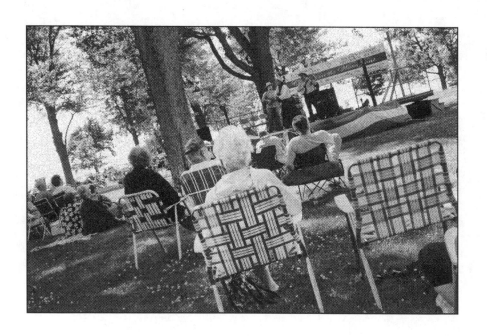

when did I cross
the border from Alice
in Wonderland
into the world
of Miss Havisham?

winter solstice
was it so important
to be young and pretty . . .
this shame
at getting old

my aging dog
crawls beneath the bed—
like me, does he hope
no one will notice
he's no longer young

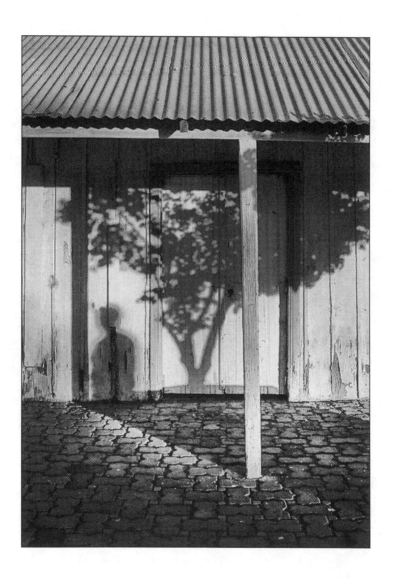

on the screen
other stories
other lives
we're in Plato's Republic
staring at shadows

after weeks of work
the monk sweeps apart
his sand mandala—
why do I cling
to these poems

*used to*
has become my verb of choice
though many insist
there's no such thing
as time

being dragged
across a border
into bone country
    frost scars
    the grass

*Peggy Heinrich*

Oahu beach
I decide to start
a travel journal
but the breeze is so balmy
the waves so inviting . . .

              at the waterfall
              mice race around rocks
              scattering dust
              the skylark soars
              higher and higher

      upset again
      by the evening news
      when will I learn
      to just stare at the stars
      and breathe?

           I drop
           into the pond of my self
           to swim with a memory—
           how heavy the resistance
           to resurface to now

Municipal Garden
almost all who enter
pat the waiting cat;
where shall I park myself
to receive a loving touch

        scent of lilies
        when the time comes
        tell me
        that I'm dying well
        ever hungry for praise

strands of hair
whip my cheeks
along this narrow road
Bashō's face peers down
from the harvest moon

        bright summer day
        thoughts fly too fast
        to capture in words;
        I'll stop by this stream
        and just let it talk to me

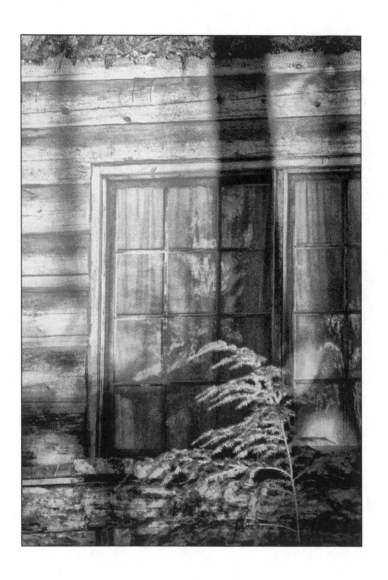

there's someone else
my long-dead husband
informs me . . .
waking
in a cold bedroom

      clear winter day
      dead ahead
      my shadow moves forward
      much larger
      than I

            I wander
            through the past
            with all its twists & turns
            I still would choose
            this life

                long-fingered leaves
                wave in the wind
                nothing is still
                under a steady
                traveling sun

IN MEMORIAM: 9/11

TWIN TOWERS

you didn't come home
the hand that was found
was it yours?
what I loved in you
was more than *body*

doors locked
stairs gone
elevators not working
flames chasing you
the smell of gasoline

did you fly
from a window
a flaming phoenix
never to rise
from ashes?

did you wait
knowing
no way out
your throat closing
around the smoke?

did you pray
for help
your hourglass
running out
of sand?

what did you think
that rumble was—
floor upon floor
piling down
toward you?

do you lie whole
in a concrete grave
a flower pressed in stone
petals scattered
like Osiris?

I cannot
picture you
whole
in parts
reduced to ash

afterwards
the inner cry
winds through my breath
waits
behind my eyes

months later
still imagining
the unimaginable
still writing
the unspeakable

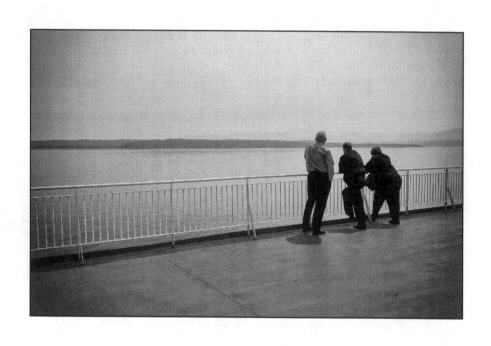

water does that
gets you staring
eyes half-closed
forgetting
remembering

## About the poet

Peggy Heinrich's seven books of poetry include *Peeling an Orange*, a collection of her haiku, many of them award-winning; *A Minefield of Etceteras*, which contains many of her published longer poems, and a mini-chapbook, *A Patch of Grass*, published by High/Coo Press in 1984.

Several of her poems were the haiku part of *Haiga-Haiku*, a book of etchings produced by artist Barbara Gray. *Forward Moving Shadows* is her first book of tanka, most of which have appeared in leading tanka journals. A native New Yorker, she resettled several years ago in Santa Cruz, California, after many cold winters in Connecticut and to be closer to her two West Coast daughters.

## About the photographer

John Bolivar is an award winning photographer and writer with degrees in botany and photography. His work has graced the ads of many commercial clients including Patagonia, UPS, REI plus Outside, National Geographic, Sierra and many other magazines. He was a runner-up in the Nikon International Photo Contest and has won many other awards.

He also provided the photographs for *Peeling an Orange*, Heinrich's book of haiku, published by Modern English Tanka Press in 2009. He is working on a book of his garden photographs, many of which have been on display at a Seattle gallery. He was the web editor for Canoe & Kayak Magazine and currently edits on a free-lance basis. He resides in Seattle with his wife and twelve-year-old son and a menagerie of rats, chickens, fish, cats and over 275 species of garden plants.